Roy, Jennifer Rozines

No Lex 10-12 Stains noted 10-29-12 CR PEACHTREE CITY LIBRARY 201 WILLOWBEND ROAD PEACHTREE CITY, GA 30269-1623

Norman Rockwell

The Life of an Artist

Jennifer Rozines Roy Gregory Roy

Enslow Publishers, Inc. 40 Industrial Road PO Box 38 Box 398 Aldershot Berkeley Heights, NJ 07922 Hants GU12 6BP USA UK http://www.enslow.com

Norman Rockwell

Copyright © 2002 by Enslow Publishers, Inc.

All rights reserved.

No part of this book may be reproduced by any means without the written permission of the publisher.

Library of Congress Cataloging-in-Publication Data

Rozines Roy, Jennifer, 1967-Norman Rockwell : the life of an artist / Jennifer Rozines Roy and Gregory Roy. p. cm. — (Artist biographies) Includes index.
Summary: Examines the life and work of the twentieth-century artist, who for sixty-five years portrayed America for Americans as they liked to see themselves. ISBN 0-7660-1883-0 1. Rockwell, Norman, 1894-1978—Juvenile literature. 2. Painters—United States— Biography—Juvenile literature. 3. Illustrators—United States—Biography—Juvenile literature.
[1. Rockwell, Norman, 1894-1978. 2. Artists. 3. Painting, American.]
I. Roy, Gregory. II. Title. III. Series: Artist biographies (Berkeley Heights, N.J.) ND237.R68873 2002 759.13—dc21 [B]

2002011982

Printed in the United States of America

10987654321

To Our Readers: We have done our best to make sure all Internet addresses in this book were active and appropriate when we went to press. However, the author and the publisher have no control over and assume no liability for the material available on those Internet sites or on other Web sites they may link to. Any comments or suggestions can be sent by e-mail to comments@enslow.com or to the address on the back cover.

Illustration Credits: American Artists in Photographic Portraits, Dover Publications, Inc., 1995, p. 13; Collection of the Norman Rockwell Museum at Stockbridge, Norman Rockwell Art Collection Trust, pp. 15, 17, 21, 25, 39, 40; Collection of the Norman Rockwell Museum at Stockbridge. Photo by Louie Lamone, p. 33; Collection of the Norman Rockwell Museum at Stockbridge. Photographer Unknown, p. 5; Defense Visual Information Center/Department of Defense, p. 27; New York Then and Now, Dover Publications, Inc., 1976, p. 6.

Cover Illustration: American Artists in Photographic Portraits, Dover Publications, Inc., 1995

Contents

1	Introducing Norman Rockwell 4
2	Becoming an Illustrator
3	Cover Stories
4	The "Four Freedoms" 24
	In the Studio: Getting the Details 30
5	Illustrating the Events of His Day 32
6	Norman Rockwell Lives On 37
	Timeline
	Words to Know
	Find Out More-Internet Addresses 46
	Index

Chapter 1

Introducing Norman Rockwell

Norman Rockwell has been called the most famous and beloved painter in the world. His pictures of ordinary people doing ordinary things tell the story of America.

Rockwell painted seven days a week for most of his life. He created nearly four thousand pictures, including eight hundred magazine covers and ads for more than 150 companies. His most famous paintings were 324 magazine covers. Millions of people saw his work month after month, year after year.

This photo shows a young Norman Rockwell (center) standing in front of his easel.

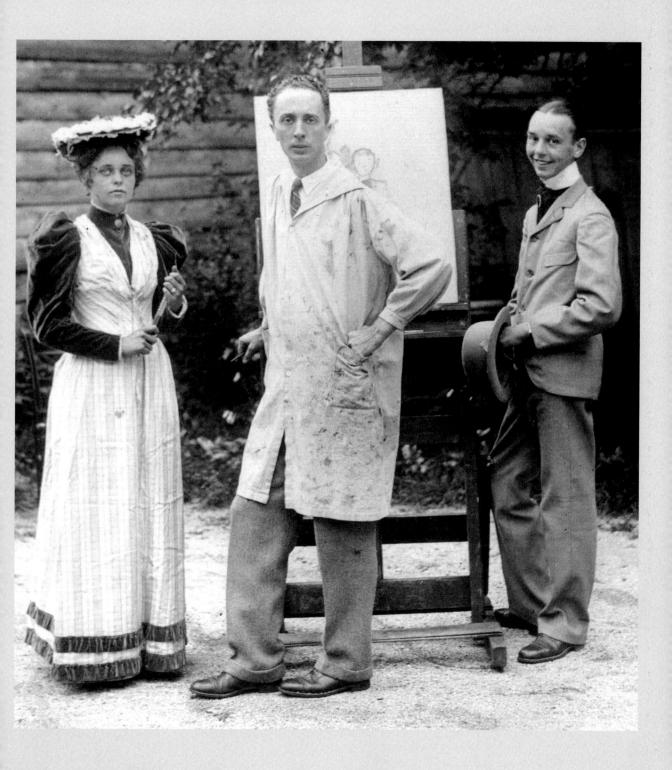

Many years after his death, people still see his paintings in museums, magazines, books, and even on stamps.

Norman Rockwell's paintings honor the best qualities of the country he loved. They make people feel that the world is a safe and friendly place.

This shows New York City more than a hundred years ago, in the 1890s. Rockwell was born in the city in 1896. You can see a trolley car in the front.

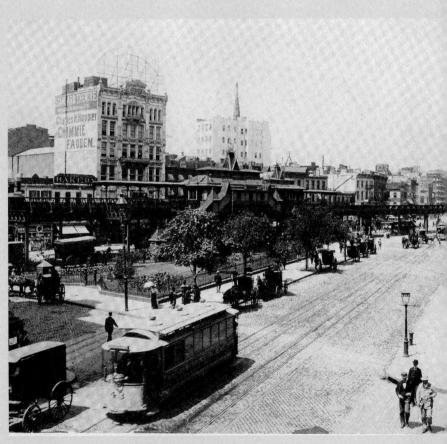

Not everybody thinks Norman Rockwell is a great artist. Many art critics have said that his pictures are rather silly and not serious art. They have said that a real artist does not make as much money as Rockwell did. But Rockwell did not paint for them. He painted for regular people.

Norman wanted to create a world of happiness in his pictures that was unlike his sad, sometimes lonely childhood. Although he said his family was "a nice family," he did not feel like he fit in.

Norman Percevel Rockwell was born on February 3, 1894. His family lived on the fifth floor of an apartment building in New York City. His father, Jarvis Waring Rockwell, was a quiet, stern man. He worked in the office of a textile company. Nancy Hill Rockwell was a homemaker who was sick in bed most of the time. Mr. Rockwell fussed over his wife quite a bit, but he was not as loving with his sons. He treated Norman and his older brother, Jarvis, like grown-ups. Their home was usually quiet and serious.

The neighborhood the Rockwells lived in was a bit rough. There were street gangs who got into fights. The children played games, such as tag and touch football, on the sidewalks and in the alleys. The kids who were strong and good at games were the most popular. Norman's brother, Jarvis, was very good at games. He was always picked for teams.

Norman, however, was clumsy and his feet turned in. He was forced to wear special heavy shoes to fix his feet. Norman was the slowest runner on the block and did not often join the other kids in their games. Norman did not like the way he looked. He was so pale that his mother nicknamed him "Snow-in-the-Face." He had skinny "spaghetti arms," and his Adam's apple stuck out. The other children called him "Moony" because of the round rimless glasses he wore.

But Norman did have a special talent. He sure could draw! He started drawing when he was about four or five, and he never stopped. His father and his grandfather, an English artist who painted animals and birds, both inspired him. "I think I've always wanted to be an artist," Rockwell said many times. "I certainly can't remember ever wanting to be anything else."

Becoming an Illustrator

napter

2

Young Norman found out what he liked to do best by watching his father sketch copies of pictures from magazines. The two spent many evenings drawing together at the dining room table. Mr. Rockwell also read stories aloud to the family. Norman drew pictures of the characters as he imagined them. Norman practiced his drawing skills at home and at school. His classmates and teachers loved looking at Norman's sketches.

When Norman's eighth-grade teacher allowed him to decorate the chalkboards with huge drawings, he was thrilled. Rockwell remembered his first "one-man displays" with happiness and pride. The praise he got made him feel sure he could do whatever it took to become an artist.

Norman worked at part-time jobs to save up money for art school. He delivered mail on his bicycle. He taught sketching to future actress Ethel Barrymore. He was even an "extra" in some performances at the Metropolitan Opera. Norman earned enough money to take classes at the Chase School of Fine and Applied Art in New York.

The Rockwells had moved to a town north of the city, so

This photo shows Rockwell as a young man. Norman had to take a long trip by trolley and subway to get to the school. Twice a week he made the four-hour round-trip journey.

Norman soon realized that he did not have enough time for high school, art classes, and work. He dropped out of high school to enter the National Academy of Design in New York. Norman's parents were disappointed. They wanted him to finish school and get a "real job." They thought most artists were poor. But Norman took his career seriously. He knew he could do well as an artist.

At the National Academy, Norman drew for eight hours a day six days a week. It was good training, but it was tiring. Norman switched over to the Art Students League. It was a better place for him.

Over the next three years, Norman studied art. He decided to become an illustrator. Illustrations are pictures that all people can understand. They are sold to companies and publishers and printed in magazines, storybooks, and calendars. When Norman was in school, some illustrators were so well known they were treated like movie stars.

Norman Rockwell's first illustrating job was for a book called *Tell Me Why Stories*. He was paid \$150 for twelve pictures. Then he drew pictures for a handbook for *Boy's Life*, a Boy Scout magazine. The editor was so pleased, he made Rockwell the magazine's art director. Norman was just nineteen years old. Over the next sixty years, Rockwell would paint the covers for almost every Boy Scout calendar.

Rockwell also did some illustrations for advertising companies. He painted ads for toothpaste, cereal, soda, and cough medicine. He received a lot of money for his work. Rockwell was proud that he was becoming popular, but he was not yet satisfied.

The best thing that could happen for an illustrator was to be chosen to paint a cover for the *Saturday Evening Post*. Millions of people all over the world used to read this magazine. Rockwell dreamed of being a cover artist but was too nervous to try. He was afraid the editor would laugh at him. A friend finally got him to take five pictures to the *Saturday Evening Post* office.

The magazine's editors liked them. They bought two of his paintings and asked him to do three more.

"Wow!" Rockwell later said about that time. "A cover on the *Post!* I had arrived."

Boy With Baby Carriage. This was the first Rockwell picture to appear on the cover of the *Saturday Evening Post*, in 1916. Rockwell was only twenty-two years old.

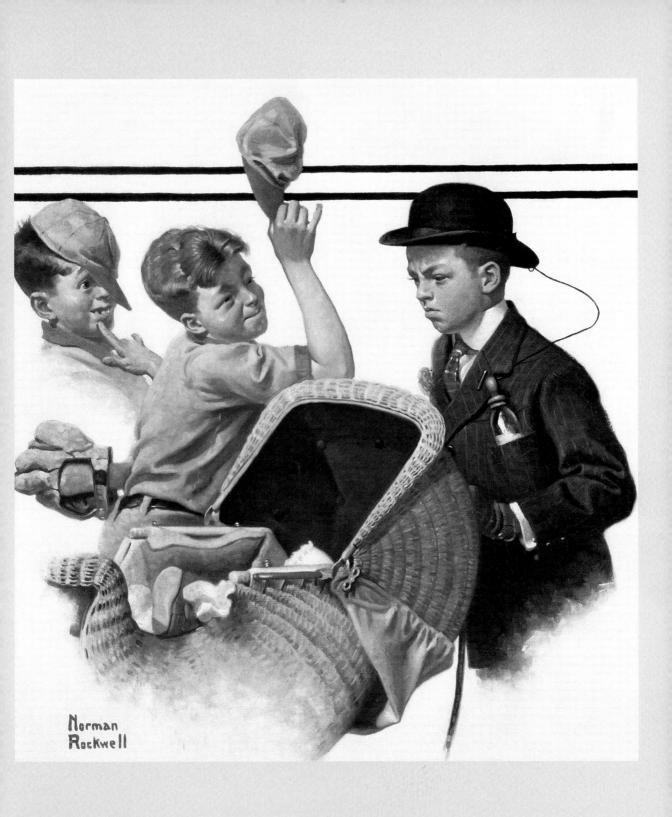

Cover Stories

chapte

Norman Rockwell's first *Post* cover was called *Boy With Baby Carriage* (1916). It shows an unhappy boy pushing a baby carriage past his friends, who are running off to play baseball. The illustration was very well liked. Rockwell did many more covers. Readers of the magazine were delighted by his pictures. More people bought the magazine when there was a Rockwell painting on the cover. That made the *Post*'s publishers very happy.

Saying Grace. This painting shows a woman and a young boy saying a prayer before they eat their meal in a diner. It was the Saturday Evening Post's cover for November 24, 1951. Post readers voted it their favorite cover.

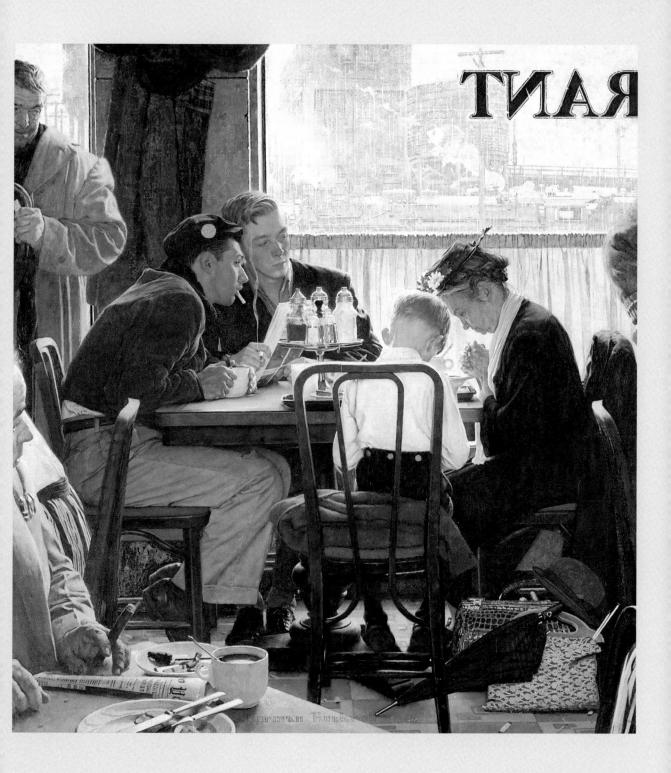

Rockwell's *Post* covers were sometimes funny scenes about childhood. One was of a surprised little boy who discovers a Santa Claus suit in his parents' dresser. Another was of a girl with a black eye smiling outside the principal's office. Another was of some boys running past a "No Swimming" sign, who look like they have just been swimming. Other covers showed families, couples in love, and animals.

Years later, millions of *Post* readers voted for their favorite Rockwell cover. They chose *Saying Grace*, a painting of an old woman and young boy praying in a diner. It was a simple scene about ordinary people, but it touched people's hearts.

Rockwell's best subjects were "ordinary folks"—people who were not special, people

whom you might see every day. But he also painted famous people, such as presidents and movie stars.

Since his days in art school, Rockwell had used real people as models. He asked neighborhood children to pose for him. He paid them fifty cents an hour. The kids liked the money, but the job was hard. It was not easy to sit still in the same position for hours. Sometimes they had to keep a smile or frown on their face or hold an uncomfortable position for a long time.

Norman placed stacks of nickels on the table to show the children how much they had earned so far. "Here's an extra nickel," he would say to keep his models cheerful. Although he was very serious about his painting, he joked and played music for the kids. In these early years, the children and adults who modeled for him were proud to see their faces on the covers of magazines. It made all the hard work of posing worthwhile. Later in his career, Rockwell used photographs instead of live models.

Norman Rockwell's illustrations were always created carefully. First, he had to come up with an idea. He thought and doodled and read and looked around until he found one he liked. Then, he made small sketches. He shared them with the editor or art director, who also had to like them. Next, Rockwell chose his models. He made large black-and-white drawings of them.

Girl With Black Eye. This tough little girl is clearly pleased with whatever just went on in the playground. Rockwell was famous for telling little stories like this with his paintings.

HUMPHREY—THE MAN IKE TRUSTS WITH THE CASH By Joseph and Stewart Alsop

Case History of a Maniac Who Was TURNED LOOSE TO KILL

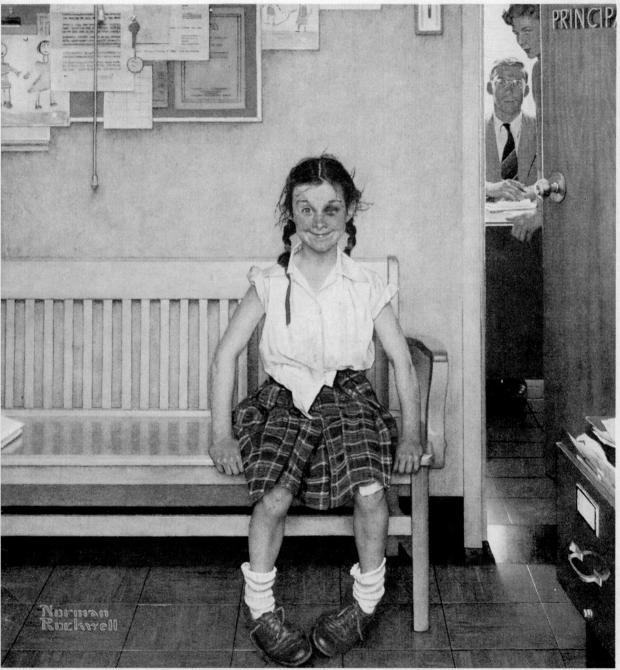

Then, it was time to add color. Rockwell tested different colors until he was satisfied. Finally, he painted with oil paints on canvas. When the painting was done, it was delivered to the magazine. The magazine printed thousands and thousands of copies for all the world to see.

Norman Rockwell's life as an illustrator was very successful. His love life, however, had its ups and downs. Rockwell married Irene O'Connor in 1916, soon after his first *Post* cover was accepted. Irene liked to party and play, while Norman was happier working. The couple divorced in 1929.

The following year, Rockwell met a schoolteacher named Mary Barstow. They fell in love and married. Norman and Mary were very happy. They had three sons—Jarvis, Thomas, and Peter. The family moved to Arlington, Vermont, when the boys were young. The small town was a good place for Rockwell. He had been feeling less confident about his artwork. Also, he was unhappy living in the city. Rockwell enjoyed the quiet countryside. His new friends and neighbors could not wait to be models for Rockwell's illustrations. In Vermont, he would paint many of his most popular pictures.

The "Four Freedoms"

4

Late one night in 1942, Norman Rockwell jumped out of bed, very excited. He had just gotten the best idea he thought he had ever had.

The country was fighting in a terrible war called World War II. American and British soldiers were fighting against Germany, Italy, and Japan. Rockwell was very patriotic—he loved his country a great deal. He wanted to help America, but he was too old to fight. Years earlier, during World War I, Rockwell

Four Freedoms. (clockwise from top left—Freedom of Speech, Freedom of Religion, Freedom From Want, Freedom From Fear) These paintings were inspired by a speech by President Franklin D. Roosevelt in 1941. They were so popular that the government sold posters of them to the public.

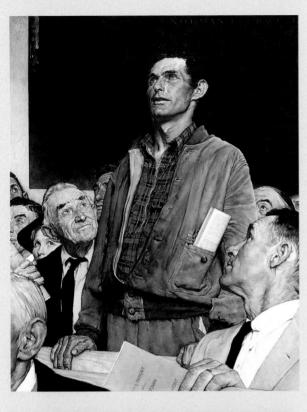

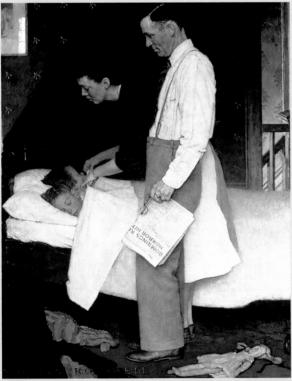

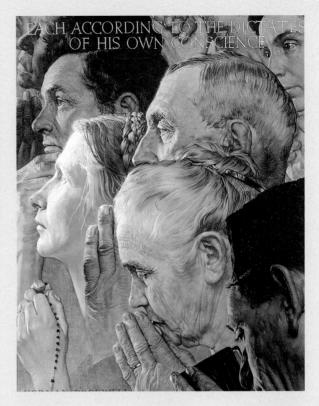

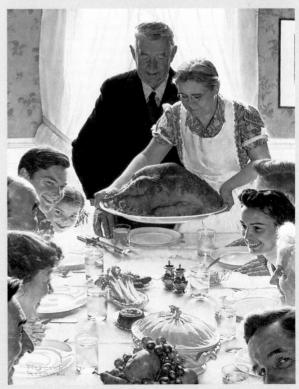

had joined the U.S. Navy. He drew portraits of navy men that they would send home to their wives. Now, he decided to use his art once again to help people feel better during a war.

President Franklin Roosevelt had spoken to the nation about four basic freedoms that people had. "The first is freedom of speech," the president said. "The second is freedom of every person to worship God in his own way. The third is freedom from want. The fourth is freedom from fear."

Norman Rockwell decided to show these four freedoms the way average Americans lived them. The idea came to him at three o'clock in the morning. Rockwell was so thrilled, he could not go back to sleep. He rode his bicycle over to a friend's house. He woke him up and told him the plan. The friend agreed that it was a wonderful idea. Rockwell went back home to begin.

A few days later, Rockwell drew sketches of the four freedoms and took them to Washington, D.C. The people in the government were not interested. They told Rockwell they wanted "real artists" for this war, not illustrators.

Rockwell was disappointed. He left Washington. On his way home, he stopped in at the *Saturday Evening Post* office. The new editor, Ben

Rockwell painted the picture for this poster to help raise money for the American effort in World War II (1941–1945). Hibbs, liked the four drawings so much, he wanted them as covers for his magazine. Rockwell was thrilled. He promised to finish them in a few months.

The paintings turned out to be much more difficult than he expected. Rockwell struggled for six months to get them just right. Finally, he was satisfied. The four paintings were done.

The first painting, *Freedom of Speech*, shows a man standing tall in a room as his neighbors listen to him speak his mind. *Freedom of Worship* shows a group of people praying. The people are of different faiths and races. For *Freedom From Want*, Rockwell painted a happy family at a Thanksgiving table. In *Freedom From Fear*, parents are tucking their children safely into bed.

The paintings were published in the *Post.* They were a tremendous success. The United States Treasury Department took them on a traveling show. Rockwell's series helped raise nearly \$133 million for the war. Over one million people saw the paintings. Seventy thousand wrote to Rockwell to say how much they loved them. Millions of prints were sold around the world. It was Norman Rockwell's biggest triumph. He was more admired, and more famous than ever.

A few days after Norman Rockwell sent the finished *Four Freedoms* to the *Post*, a terrible thing happened. His studio caught fire and burned down. He lost many paintings and sketches. However, he was grateful that the *Four Freedoms* paintings were safe. He built a new studio and got back to work.

In the Studio

Getting the Details

If you look closely at Rockwell's paintings, whether you love his art or not, you cannot help but be amazed by the details he shows. Every object has a lot of little things to notice about it. That is part of what makes his art so likeable.

How did he manage to come up with such realistic details? One of his tricks was that he used good props and costumes. When a person is drawn or painted by an artist, that person is called a model. When objects are drawn or painted, those objects are called props. Rockwell liked to use his neighbors in Vermont as models. He had a large collection of costumes for them to wear—but not Halloween costumes. He kept such things as old, worn blue jeans or old hats. He wanted his models to look like real people. All his props were used items, because he felt they would look right only if they had been used by real people.

He would set up the scene by posing the models and placing the props where he wanted them. He would then do a charcoal sketch of the scene. Next, he would experiment, using oil paints, until he decided exactly how the picture should look. Then, he would paint the final oil painting.

In the 1930s, Rockwell worked with a camera. He would set up his scenes and photograph them. He would paint while looking at the photographs rather than at live models. This way, he could paint without making people stay in one position for too long.

Illustrating the Events of His Day

apter

5

In 1953, the Rockwells moved to Stockbridge, Massachusetts. Norman's wife, Mary, was not well. Stockbridge was closer to her doctors. While Mary was sick, Rockwell and his son Tom wrote *My Adventures As an Illustrator*, a book that told Rockwell's story in his own words.

Six years after the move, Mary died. Rockwell was sad and lonely without his wife.

This photograph shows Rockwell with his painting *JFK's Bold Legacy.* It shows President John F. Kennedy and members of the newly formed Peace Corps. The Peace Corps sends Americans to help people in other countries.

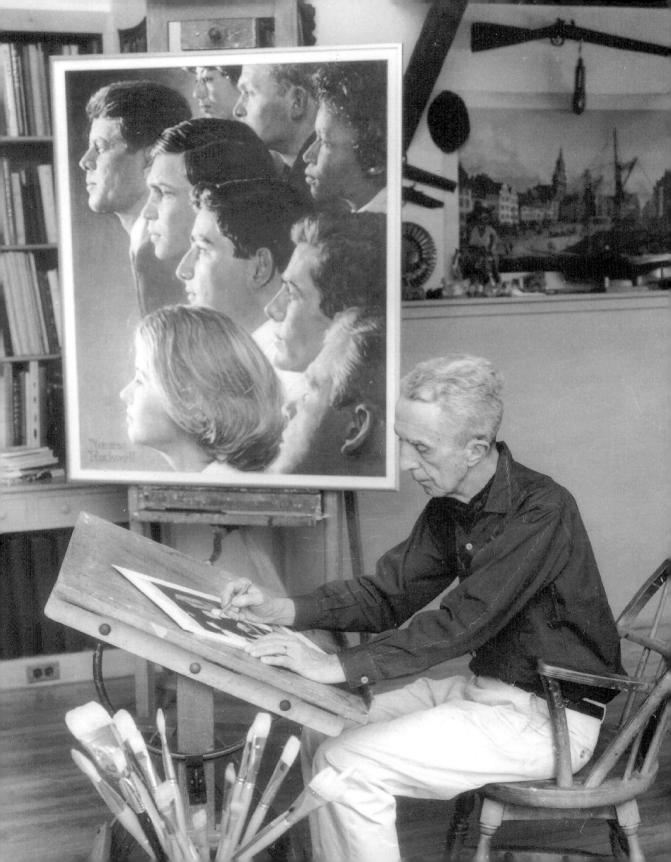

After a couple of years, he met and married Molly Punderson, a retired teacher. Rockwell's third marriage was also a good one. He and Molly traveled around the world. Rockwell painted many important people on his trip.

In 1963, forty-seven years after his first cover, Rockwell stopped working for the *Saturday Evening Post*. He was not happy with the way the new staff treated him. He was ready for a change.

Other magazines asked Rockwell to illustrate pictures of the changing nation. Rockwell made an illustration for *Look* magazine. It was called *The Problem We All Live With*. It shows a sweet, little African-American girl walking into an allwhite school. She is protected by soldiers. At that time, a new law said that black children and white children should go to the same schools. Many people, especially in the South, had a hard time accepting that idea. Black people and white people had always been kept apart. With one picture, Rockwell was able to tell the story of this powerful argument that was going on in the United States.

Rockwell also made paintings about a black family moving into a white neighborhood. He painted the *Apollo 11* space landing. His illustrations had told the story of the United States, from people riding on horse-and-buggies to a man walking on the moon.

In July 1976, America celebrated its two hundredth birthday. Rockwell painted a picture of himself wrapping a ribbon around the Liberty Bell. It was Norman Rockwell's last magazine cover. He was eighty-two years old. He had been illustrating covers for sixty years.

The following year, President Gerald Ford honored Norman Rockwell with the Presidential Medal of Freedom—the nation's highest peacetime award.

Norman Rockwell once said to a friend, "Maybe the secret to so many artists living so long is that every painting is a new adventure. So, you see, they're always looking ahead to something new and exciting."

Norman Rockwell always looked forward to his next idea. He always hoped his next painting would be his best one.

Norman Rockwell Lives On

6

pte

Norman Rockwell died on November 8, 1978. By then, he had grown weak and tired. He had stopped painting, but he still drew with paper and pencil. His last picture was sitting on his easel when he passed away.

Rockwell was buried in Stockbridge Cemetery. His friends and neighbors said he was a warm person with a gentle humor. He was a good man as well as a great illustrator.

Rockwell's paintings now hang in important museums, such as the Metropolitan Museum of Art in New York and the National Portrait Gallery in Washington, D.C. Rockwell exhibits are shown around the world. The Arlington Gallery in Vermont has a popular Norman Rockwell exhibition.

The largest collection of Rockwell's work is in Stockbridge, Massachusetts. The museum contains hundreds of his paintings and drawings. Rockwell's entire red barn studio was moved to the grounds near the museum. His paintbrushes, paints, and easel are set up inside. The museum also contains some of Rockwell's personal things and some of his props. Thousands of people visit the Norman Rockwell Museum every year.

The Marriage License. Some artists might think of painting a big, fancy wedding with lots of guests all dressed up. Rockwell preferred showing things that were simple and ordinary. This Post cover shows a couple signing their marriage license in a government office.

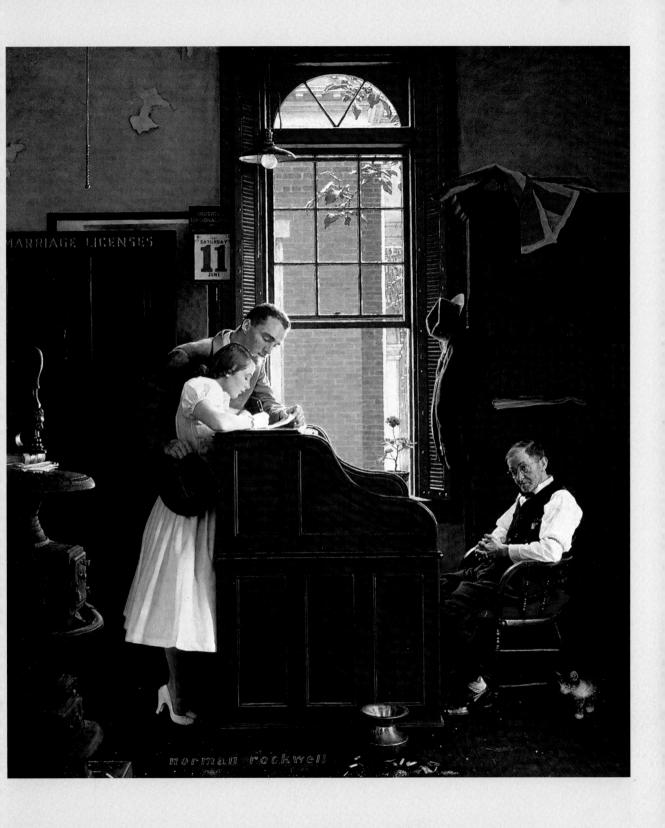

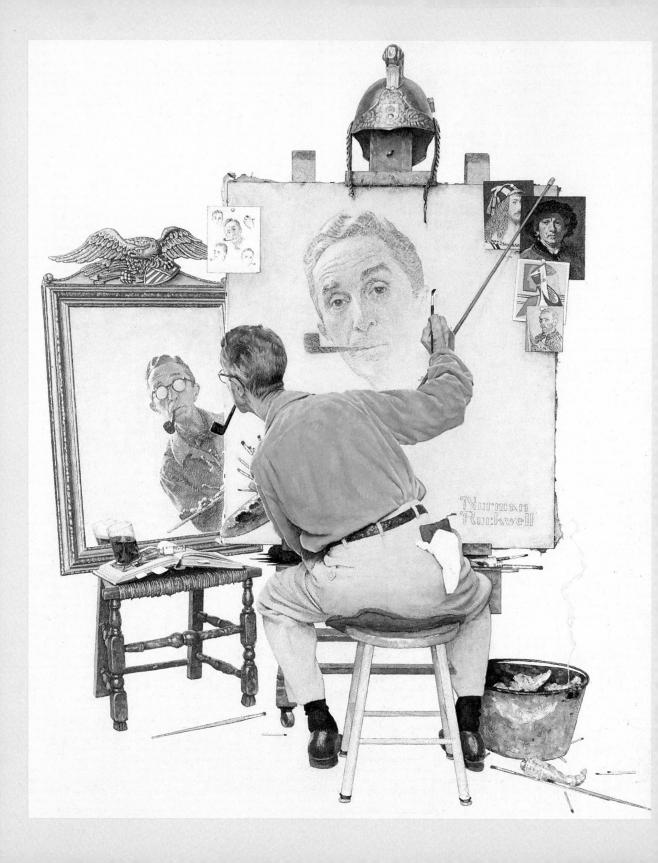

Norman Rockwell painted the stories of ordinary people, but his pictures were never ordinary. They made people feel special. They gave people hope. Norman Rockwell showed America at its best.

Triple Self-Portrait. Can you see at least three Norman Rockwells in this painting? It shows the back of his head as he paints. It also shows his face in the mirror, on the canvas, and in a smaller sketch on his easel. The four pictures on the right side of the easel are self-portraits done by other famous artists. Rockwell seems to have put them there to inspire him.

- Attends National Academy of Design.
- Attends Art Students League.
- Becomes art director at *Boys' Life*.
- Gets first *Saturday Evening Post* cover; Marries Irene O'Connor.
- Divorces Irene O'Connor.
- Marries Mary Barstow.
- 1939 Moves to Arlington, Vermont.
- *Four Freedoms* published in the *Post;* Studio burns to the ground.
- Paints Saying Grace.
- Moves to Stockbridge, Massachusetts.
- His wife, Mary, dies.
- Publishes life story.
- Marries Molly Punderson.

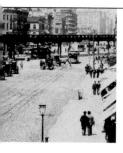

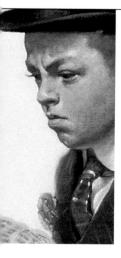

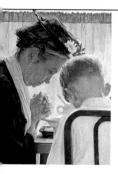

- Last *Post* cover printed.
- *Look* magazine cover published: *The Problem We All Live With*.
- Paints man's travels to the moon for *Look* magazine.
- 1976 Last magazine cover appears on American Artist.
- Receives Presidential Medal of Freedom.
- Dies at age eighty-four.
- Norman Rockwell Museum opens in Stockbridge, Massachusetts.

Words to Know

art critics — People who give opinions about art.

canvas — Strong piece of cloth artists paint on.

editor — Person who decides what goes into a magazine or book.

exhibit — Show, display.

gallery — Place where works of art are shown.

illustrator — Person who draws pictures that are published in books or magazines.

ordinary — Common, everyday, not special.

patriotic — Very proud of one's country.

pose — Stay very still to be painted or photographed.

series — Group of paintings that belong together in a certain order.

sketches — Quick drawings.

Norman Rockwell

Internet Addresses

The best way to learn more about any artist, including Norman Rockwell, is to see the art—the real thing, not just photographs of it. That is easy if you happen to live in a large city with a large art museum, such as New York. But if you do not, try the Internet. The Web sites for Rockwell listed on the next page were written for people of all ages, so the text may be a bit too hard for you to get through. That is okay, though—you are just visiting for the pictures.

The Norman Rockwell Museum at Stockbridge

Visit this site to get a brief biography of Rockwell and for information about this museum, in Stockbridge, Massachusetts. It holds the largest collection of Rockwell's work. Click on "Eye Openers" to see some of his works and read comments about them. http://www.nrm.org

Norman Rockwell Museum of Vermont Learn about this other terrific Rockwell museum. This site sells prints of his work online. But you do not have to buy any. You can just look at them. Just click on "Prints 1" and "Prints 2" for a large selection. http://www.normanrockwellvt.com

Rockwell Gallery Collection This site displays many examples of Rockwell's work, including some of his commercial art.

http://www.rockwellsite.com

Index

A

Apollo 11, 35 Arlington, Vermont, 23 Art Students League, 12

B

Barstow, Mary (second wife), 22–23, 32 Boy's Life magazine, 13 Boy With Baby Carriage, 14, 15, 16

С

Chase School of Fine and Applied Art, 11

F

fire, 29 Ford, Gerald, 36 *Four Freedoms*, 24, 25, 26–29

G

Girl With Black Eye, 20, 21

J

JFK's Bold Legacy, 32, 33

L

Look magazine, 34

M

Marriage License, The, 38, 39 My Adventures As an Illustrator, 32

Ν

National Academy of Design, 11, 12 The Norman Rockwell Museum, 38

0

O'Connor, Irene (first wife), 22

Р

Presidential Medal of Freedom, 36 *Problem We All Live With, The,* 34, 35 Punderson, Molly (third wife), 34

R

Rockwell, Jarvis (brother), 8 Rockwell, Jarvis Waring (father), 7, 8 Rockwell, Nancy Hill (mother), 7

S

Saturday Evening Post, 14, 16, 18, 27–28, 29, 34 *Saying Grace,* 16, 17, 18 sons, 23 Stockbridge, Massachusetts, 32, 38

T

Tell Me Why Stories, 12 *Triple Self-Portrait,* 40, 41